P9-DEC-602

Learn to Draw Manga

MANGA MONSTERS

Illustrated by
Richard Jones & Jorge Santillan

PowerKiDS
press™

New York

Published in 2013 by The Rosen Publishing Group, Inc.
29 East 21st Street, New York, NY 10010

First Edition

Produced for Rosen by Calcium Creative Ltd
Editor: Sarah Eason
Editor for Rosen: Sara Antill
Book Design: Paul Myerscough

Illustrations by Richard Jones and Jorge Santillan

Library of Congress Cataloging-in-Publication Data

Jones, Richard, 1979–
 Manga monsters / by Richard Jones and Jorge Santillan. — 1st ed.
 p. cm. — (Learn to draw manga)
 Includes index.
 ISBN 978-1-4488-7876-5 (library binding) —
 ISBN 978-1-4488-7947-2 (pbk.) — ISBN 978-1-4488-7953-3 (6-pack)
 1. Comic books, strips, etc.—Japan—Technique. 2. Cartooning—
Technique. 3. Comic strip characters—Japan. 4. Drawing—
Technique. I. Santillan, Jorge. II. Title.
 NC1764.5.J3J66 2013
 741.5'952—dc23

 2011051867

Manufactured in the United States of America

CPSIA Compliance Information: Batch #B4S12PK: For Further Information contact Rosen Publishing, New York, New York at 1-800-237-9932

Contents

"Manga" is a Japanese word that means "comic." You may have seen Manga characters in comics, TV cartoons, and films. Manga is one of the coolest illustrations styles, and now you can learn to draw Manga yourself!

Manga gets scary!

In this book, we are going to show you how to draw cute, terrifying, and awesome monsters, Manga-style!

You will need

To create your Manga characters, you will need some equipment:

Sketchpad or paper

Try to use good quality paper from an art store.

Pencils

A set of good drawing pencils are key to creating great character drawings.

Eraser

Use this to remove any unwanted lines.

Paintbrush, paints, and pens

The final stage for all your drawings will be to add color. We have used paints to complete the Manga characters in this book. If you prefer, you could use pens.

Lovable Monster

Manga monsters don't have to be frightening. They can also be cute!

Step 1

Draw simple, rounded shapes to create the outline for your monster.

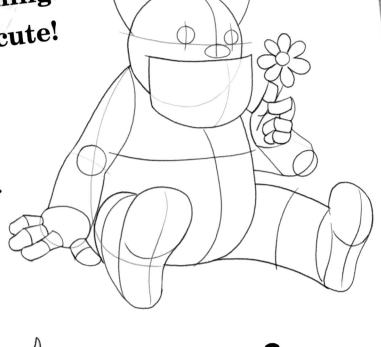

Step 2

Now add detail. Draw the monster's fur, finger- and toenails, nostrils, and tooth. Don't forget the flower!

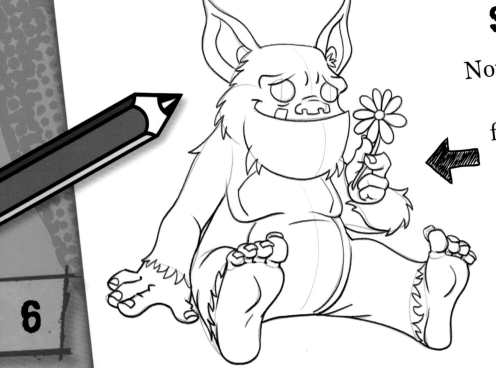

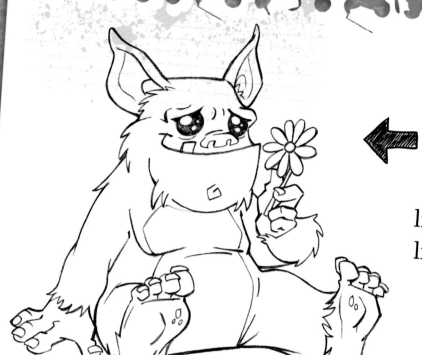

Step 3

Add shading to the eyes and fur to bring the monster to life. Keep the shading light because you will paint over it next.

Step 4

Finally, add color. Choose a pale pink for the feet, hands, ears, and stomach. A brighter pink works well for the fur. Give your monster green eyes.

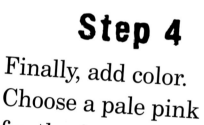

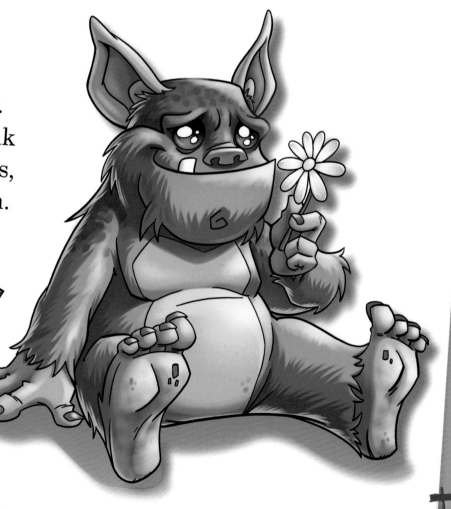

Screaming Banshee

A banshee is a terrifying female spirit. Banshees have a screeching wail that can be heard from far away. That's where the expression "screaming like a banshee" comes from!

Step 1

Create the outline for your banshee. Use long, thin cone and cylinder shapes. Divide the head and body into four parts.

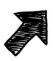

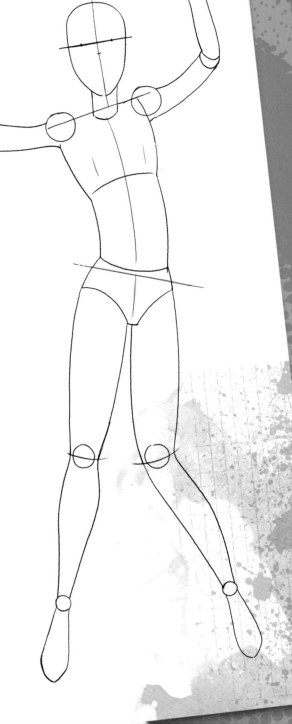

Step 2

Use a fine-tipped pencil to add detail to the outline. Draw bones and muscles on the chest and stomach. Add features to the face and nails to the fingers.

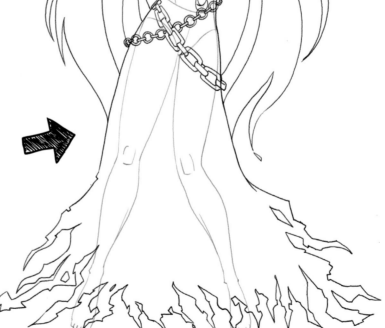

Step 3

Now you can add the clothing and hair. Draw long, wild hair and give the skirt and sleeves of the dress ragged edges. Add a chain belt.

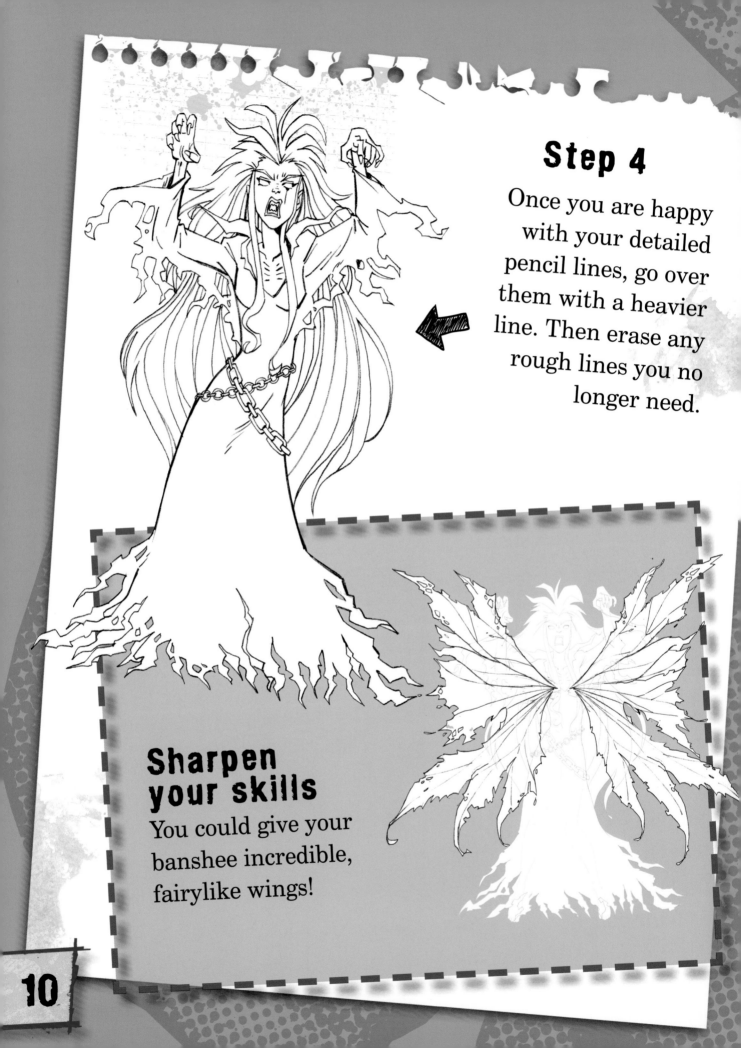

Step 4

Once you are happy with your detailed pencil lines, go over them with a heavier line. Then erase any rough lines you no longer need.

Sharpen your skills

You could give your banshee incredible, fairylike wings!

Step 5

Bring your banshee to life with color. Use a blue-gray paint for the hair and add white highlights. Color the dress with a soft purple. The chain belt could be colored in steely gray. A darker purple will make the long, sharp nails and screaming mouth stand out. Leave the eyes white. Everybody scream!

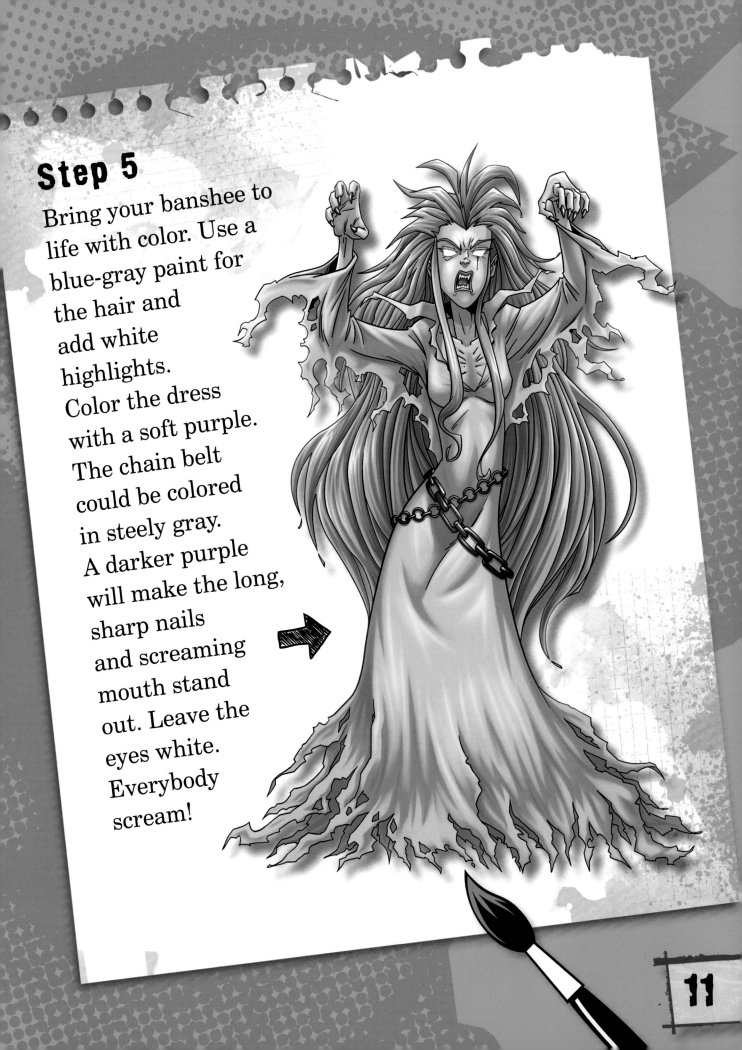

Shy Ghost

Scared of ghosts? This small creature is more likely to be terrified of you!

Step 1

Draw a simple circle for the head and a rectangle for the body. Add three small circles at the base. Pencil the arms and hands.

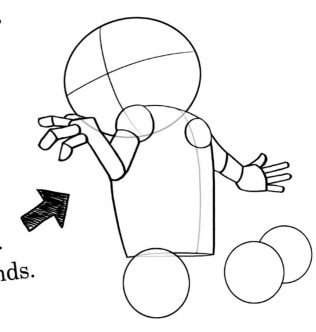

Step 2

Draw a cross through the head to mark the face. Add the eyes, hood, and cloak.

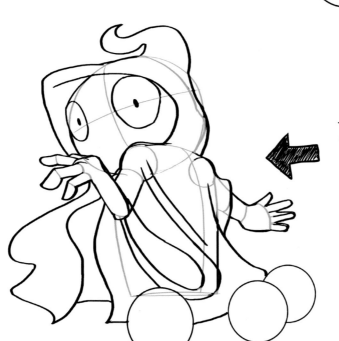

Step 3

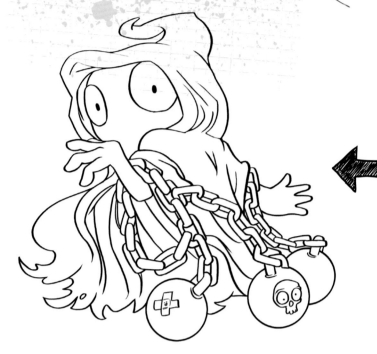

Add a chain around the arms and body. Link it to the three balls. Add a skull to one ball and a cross to another. Lightly shade the face and cloak.

Step 4

Paint the cloak and hood with a green-gray color and the arms and hands with gray. Paint the face dark brown, with a lighter brown around the eyes. Color the eyes yellow and add highlights of yellow and white to the cloak. The balls can be charcoal gray.

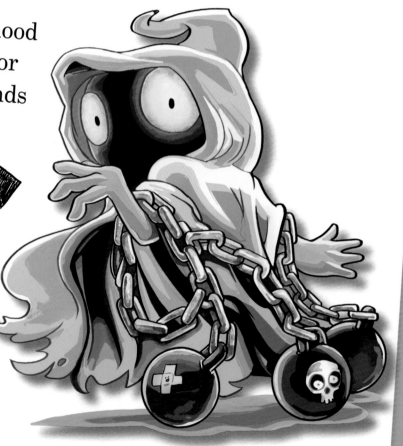

Crazy Werewolf

Terrifying creatures of the dark, werewolves are humans who turn into wolflike monsters at night, but only when there is a full moon!

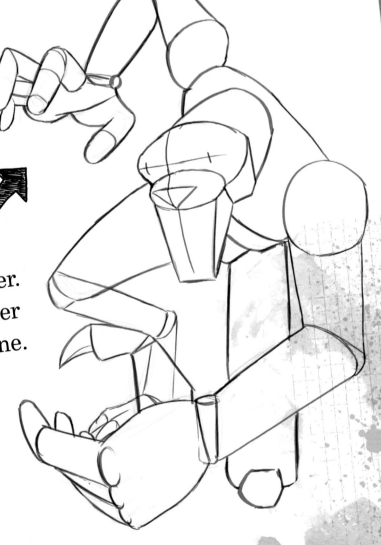

Step 1

Create a lunging pose for your monster. Use cone and cylinder shapes for the outline.

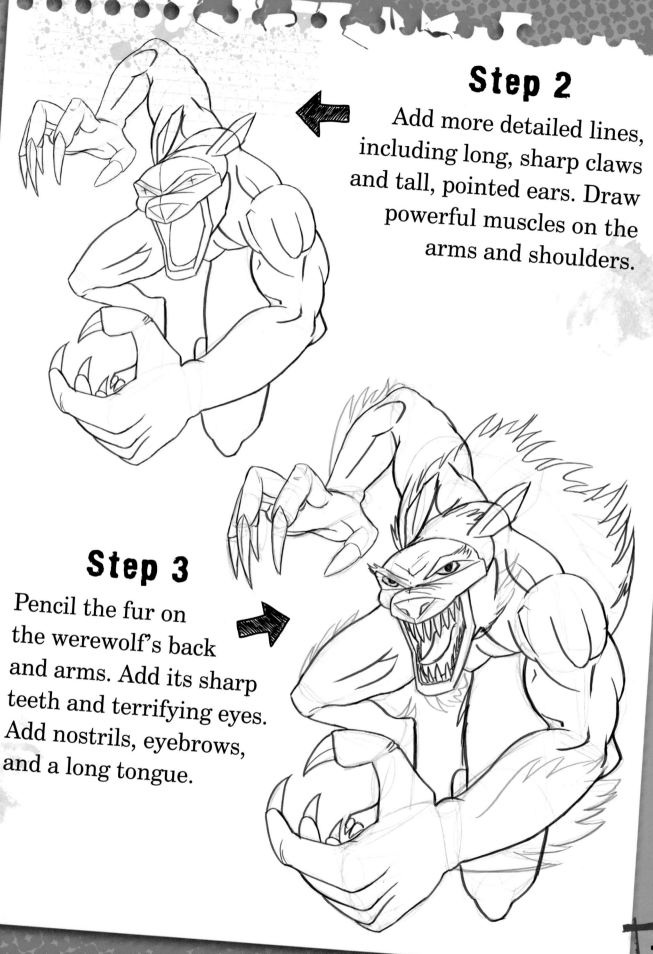

Step 2

Add more detailed lines, including long, sharp claws and tall, pointed ears. Draw powerful muscles on the arms and shoulders.

Step 3

Pencil the fur on the werewolf's back and arms. Add its sharp teeth and terrifying eyes. Add nostrils, eyebrows, and a long tongue.

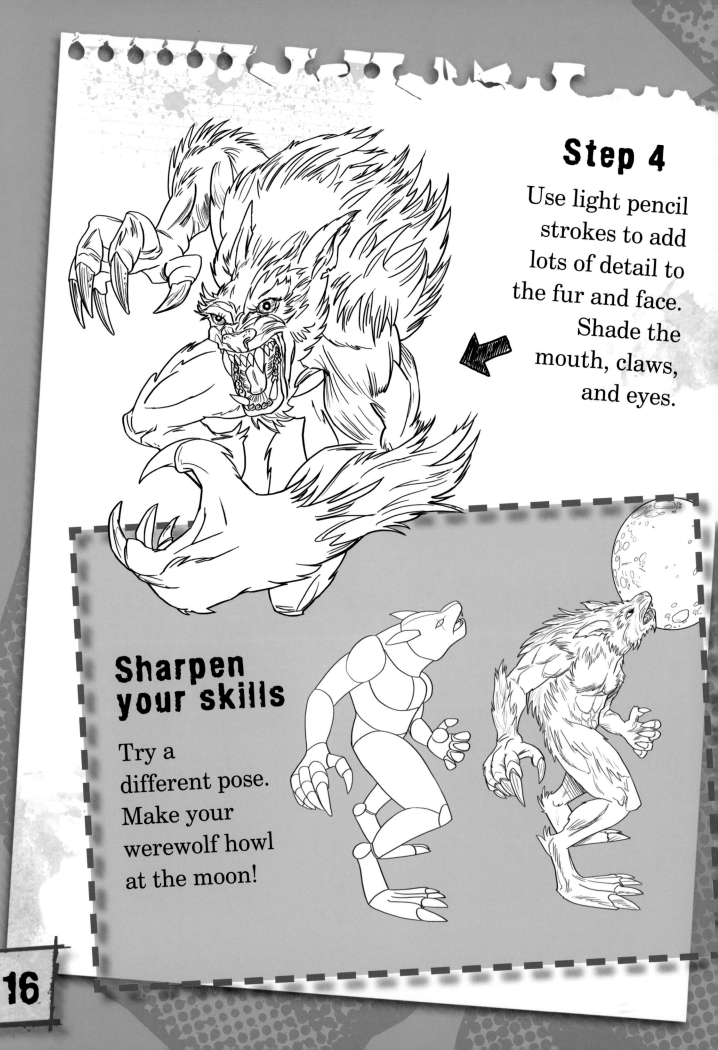

Step 4

Use light pencil strokes to add lots of detail to the fur and face. Shade the mouth, claws, and eyes.

Sharpen your skills

Try a different pose. Make your werewolf howl at the moon!

Step 5

The colors for your werewolf are simple. Mix green with gray to paint the body and fur. Add darker gray or black for shading. Add white highlights. Give your werewolf evil yellow eyes!

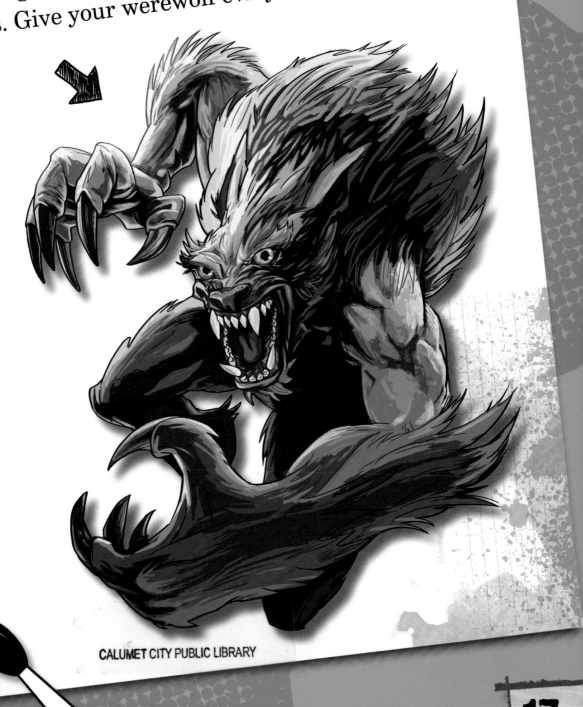

Little Devil

This devilish imp is full of mischief. He may be small, but he is packed with wicked power!

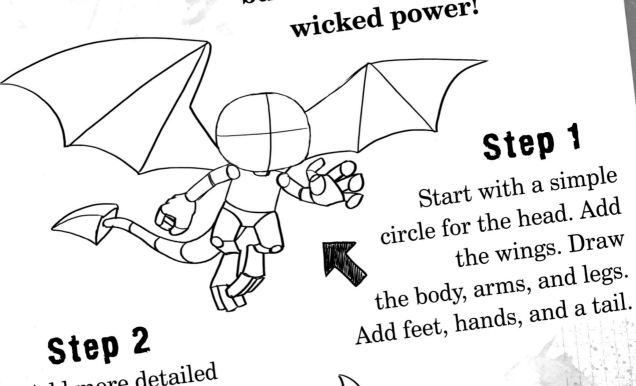

Step 1

Start with a simple circle for the head. Add the wings. Draw the body, arms, and legs. Add feet, hands, and a tail.

Step 2

Add more detailed lines to the wings. Pencil the horns, face, and ears. Add claws.

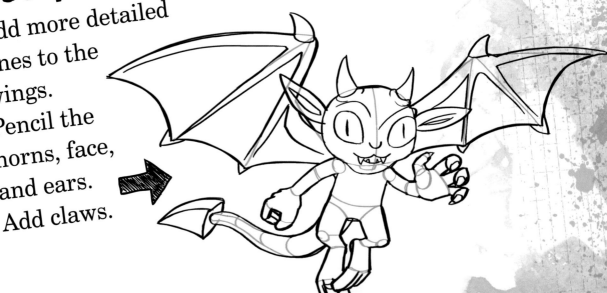

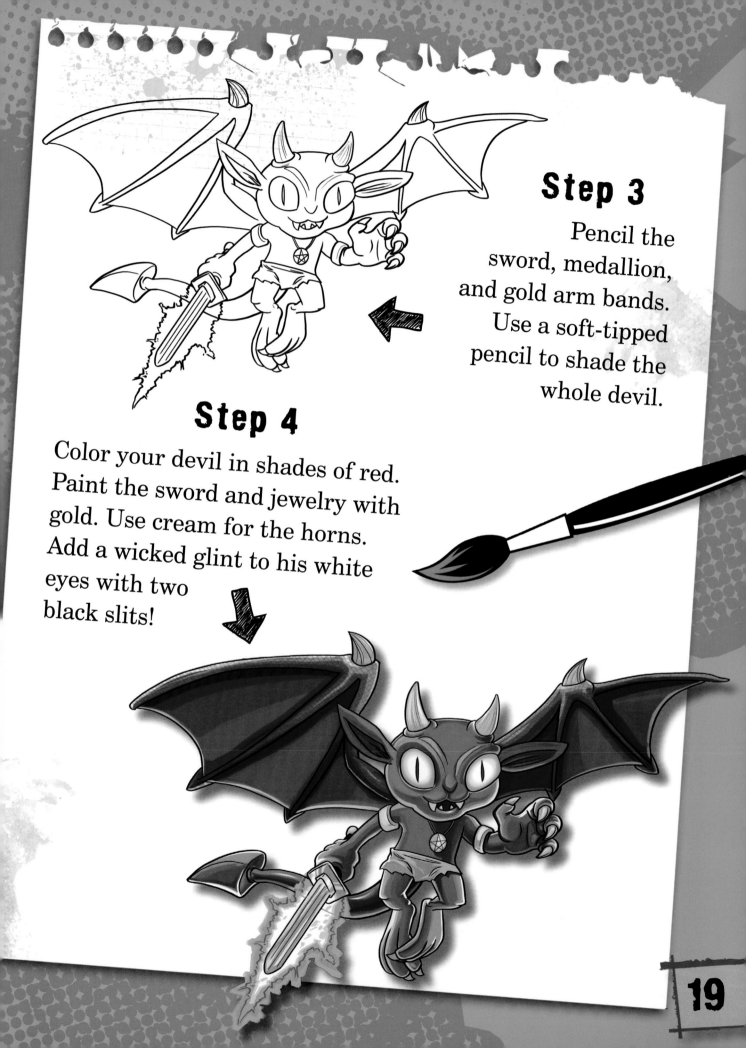

Step 3

Pencil the sword, medallion, and gold arm bands. Use a soft-tipped pencil to shade the whole devil.

Step 4

Color your devil in shades of red. Paint the sword and jewelry with gold. Use cream for the horns. Add a wicked glint to his white eyes with two black slits!

Curse of the Mummy

No monster book would be complete without a mummy. A mummy is a dead body that is covered with strips of cloth. This gruesome creature is thousands of years old and has risen from the dead!

Step 1

Create the rough outline for your character. Mummies stagger as they walk, so make your monster's legs turn inward and give him a stoop.

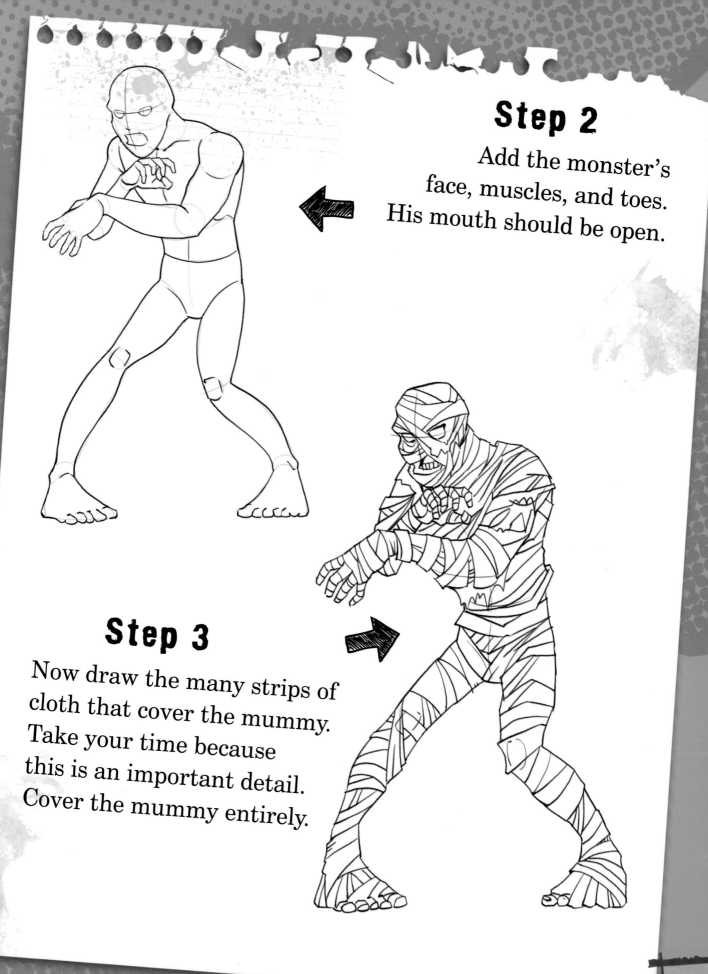

Step 2

Add the monster's face, muscles, and toes. His mouth should be open.

Step 3

Now draw the many strips of cloth that cover the mummy. Take your time because this is an important detail. Cover the mummy entirely.

Step 4

Use a very fine-tipped pencil to add extra details such as rips in the cloth and jagged teeth. Erase any rough lines you no longer want to keep.

Sharpen your skills

Try some different poses. Anything goes as long as it's scary!

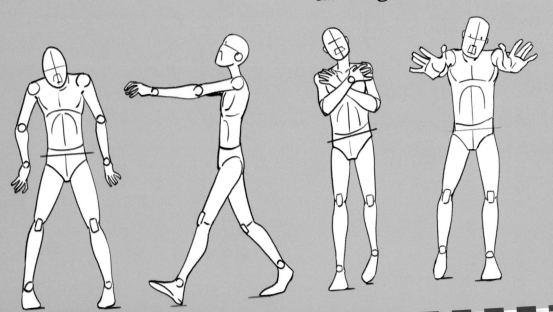

Step 5

The only thing missing from your mean-looking creation is color! Your mummy has been buried since ancient times, so use a creamy gray color for the cloth. Add touches of brown and some light blue shading. Finally, give him a pair of wicked yellow eyes!

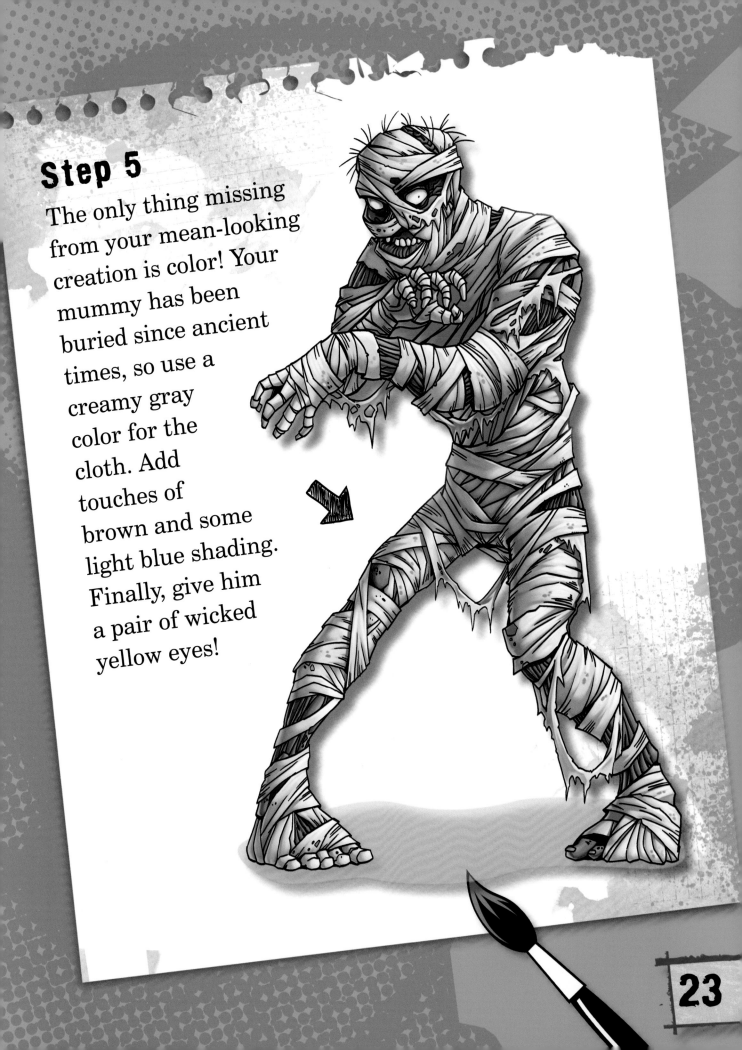

Evil Goblin

This madly grinning creature is armed with a heavy hammer and a battle-ready shield. Don't be fooled, though. He may be smiling, but there is nothing friendly about this monster!

Step 1

Set your goblin up with a fighting pose. Pencil a circle for his head, a triangle for his body, and cone shapes for his limbs.

Step 2

Add his hammer, shield, and pointed ears. Draw a wicked grin and long, evil eyes. Pencil the toes.

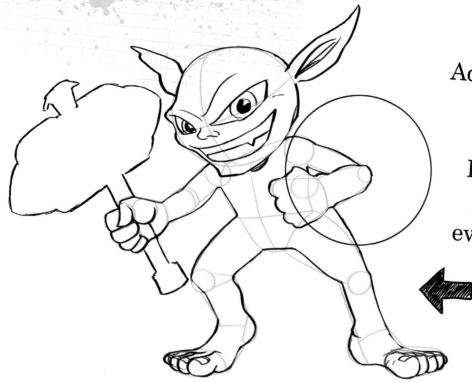

Step 3

Now add the features that will really give your goblin character. Pencil a hat, boots, and a tunic.

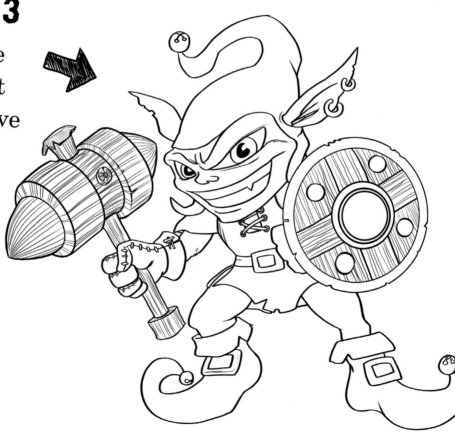

Sharpen your skills

Goblins are mean fighters! Try giving your monster a battle-ax and some cool body armor.

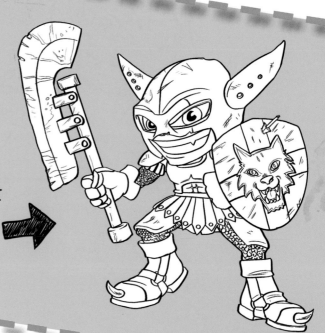

Sharpen your skills

Want to draw even more weapons? Try these fighting tools.

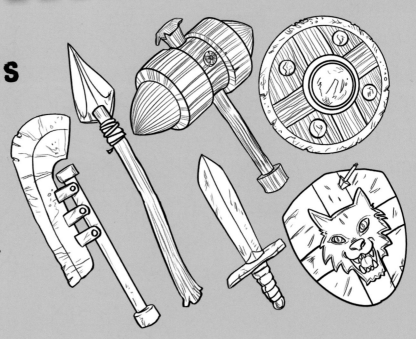

Step 4

This evil little guy has a rich purple cloak. Give him green skin and bright green eyes. Don't forget to paint the hammer, shield, bells, and earrings. Ultra-white teeth complete his goblin grin!

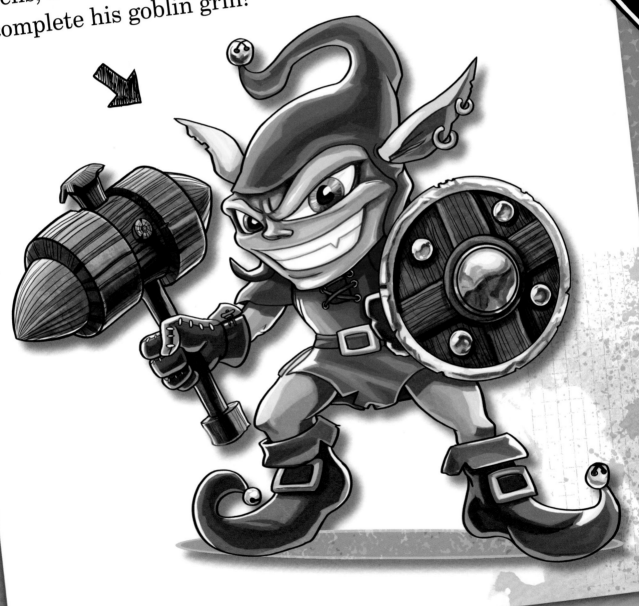

More Monsters

If you've loved drawing Manga monsters, try some more!

Ghoul

You've drawn a cute ghost, now take on this terrifying ghoul!

Siren

Try a monster from the deep, the beautiful siren.

Goblin

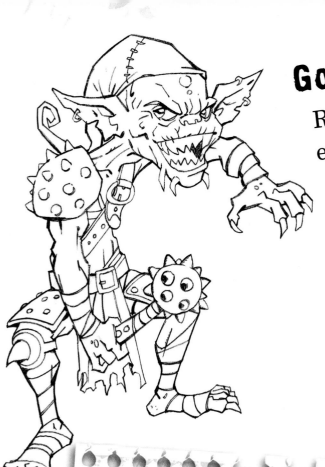

Remember that evil goblin from page 24? He has a wicked brother!

Vampire

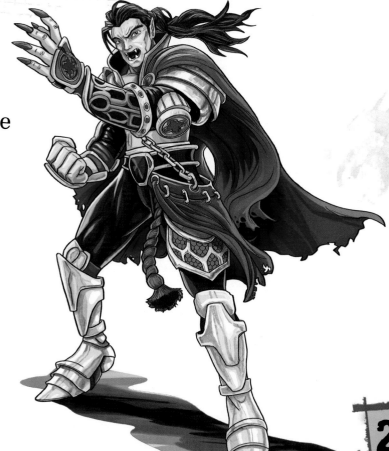

The ultimate monster warrior, the vampire. He wants to draw your blood!

Glossary

character (KER-ik-tur) A fictional, or made-up person. Can also mean the features that you recognize something or someone by.

detail (dih-TAYL) The smaller, finer lines that are used to add important features to a character drawing, such as eyes, ears, and hair.

devilish (DEH-vul-ish) Bad or evil, like the Devil.

divide (dih-VYD) To separate.

erase (ih-RAYS) To remove.

features (FEE-churz) The eyes, nose, and mouth on a face.

fine-tipped (fyn-TIHPD) A slender, sharp tip to a pencil or pen.

ghoul (GOOL) A ghost.

highlights (HY-lytz) Light parts.

jagged (JAG-ed) Rough, with sharp points.

limbs (LIMZ) Arms and legs.

lunging (LUN-jing) Moving suddenly forward.

medallion (meh-DAL-yi-on) A large, heavy necklace.

mummy (MUH-mee) A dead body wrapped in strips of cloth. Organs were removed from the body before it was wrapped.

outline (OWT-lyn) A very simple line that provides the shape for a drawing.

pose (POHZ) The way something or someone stands.

shading (SHAYD-ing) Creating lots of lines to add shadow and depth to a drawing.

siren (SY-ren) A beautiful mermaid that lives in the sea. Sirens sang songs that drove sailors mad.

spirit (SPIR-ut) A ghostlike monster.

stoop (STOOP) To bend over.

tunic (TOO-nik) A short, dresslike piece of clothing.

wail (WAYL) A cry, or a scream.

wicked (WIH-ked) Bad or evil.

Further Reading

Amberlyn, J. C. *Drawing Manga Animals, Chibis and Other Adorable Creatures*. New York: Watson-Guptill, 2009.

Giannotta, Andrés Bernardo. *How to Draw Manga*. Mineola, NY: Dover Publications, 2010.

Gray, Peter. *Monsters*. Drawing Manga. New York: PowerKids Press, 2006.

Hart, Christopher. *Ultimate Book of Trace-and-Draw Manga*. Xtreme Art. New York: Watson-Guptill, 2009.

Southgate, Anna, and Keith Sparrow. *Drawing Manga Expressions and Poses*. Manga Magic. New York: Rosen Publishing Group, 2012.

Websites

Due to the changing nature of Internet links, PowerKids Press has developed an online list of websites related to the subject of this book. This site is updated regularly. Please use this link to access the list: www.powerkidslinks.com/ltdm/mons/

Index